D1625812

WHAT IS
A MASTERPIECE?

THIS IS THE ELEVENTH OF THE
WALTER NEURATH MEMORIAL LECTURES
WHICH ARE GIVEN ANNUALLY EACH SPRING ON
SUBJECTS REFLECTING THE INTERESTS OF
THE FOUNDER
OF THAMES AND HUDSON

THE DIRECTORS WISH TO EXPRESS
PARTICULAR GRATITUDE TO THE GOVERNORS AND
MASTER OF BIRKBECK COLLEGE
UNIVERSITY OF LONDON
FOR THEIR GRACIOUS SPONSORSHIP OF
THESE LECTURES

WHAT IS
A MASTERPIECE?

KENNETH CLARK

THAMES AND HUDSON

About fifteen years ago that great publisher, Walter Neurath, asked me to write a book with the title of 'What is a Masterpiece?' I accepted with enthusiasm because I thought it would allow me to drive one more nail into the coffin of subjectivity. There were, and perhaps still are, people who used to maintain that the word masterpiece was merely the expression of a personal opinion deriving from whim and fashion. This belief seems to me to undermine the whole fabric of human greatness. In four thousand years human beings have committed many follies. Cruelty and intolerance fill the pages of history books and often, as we read about the past — and, for that matter, the present — we are aghast, and feel like withdrawing, as men did for almost four centuries, into some form of life where isolation is achieved by painful discipline. But just when we are beginning to despair of the human race we remember Vézelay or Chartres, Raphael's School of Athens or Titian's Sacred and Profane Love, and once more we are proud of our equivocal humanity. Our confidence has been saved by the existence of masterpieces, and by the extraordinary fact that they can speak to us, as they have spoken to our ancestors for centuries.

What is a masterpiece? The answer, as Walter Neurath realized, is the subject of a book rather than a lecture. But other activities pressed around me, and the book was never written. Only a few notes emerge occasionally from my disorderly papers, and prick my conscience. From the first, I had intended to base the book on examples. Abstract definitions of the word masterpiece, like abstract definitions of beauty itself, are an exercise of ingenuity, but have only a remote relationship to experience. Were I to define the word in a phrase I would at once become aware of a host of exceptions pressing round me like lost souls in limbo, begging to be given life. 'Why have you forgotten me?' I could not get their cries out of my ears.

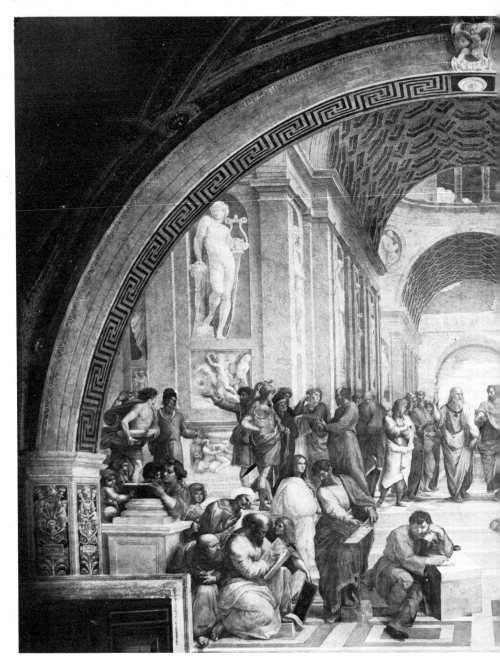

1 RAPHAEL, *The School of Athens* (The Vatican, Rome)

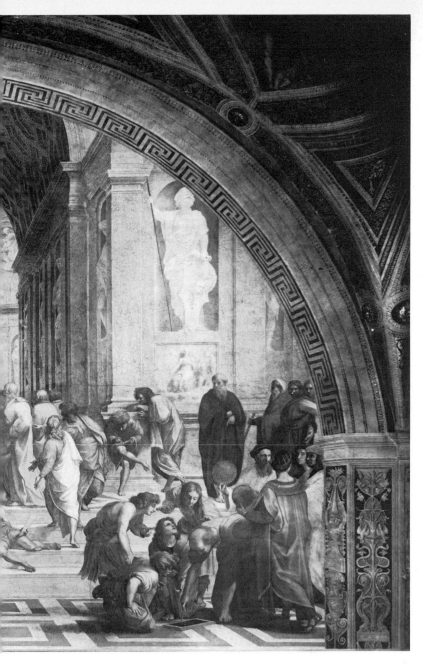

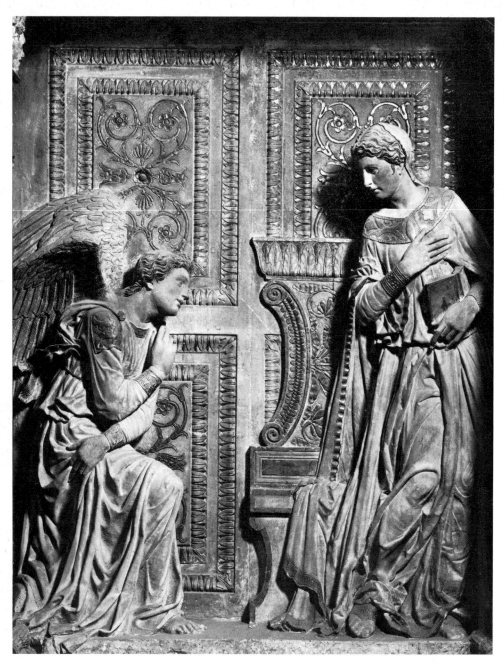

2 DONATELLO, *Annunciation* (Sta Croce, Florence)

ALTHOUGH we may disagree about a theory, the impact of a masterpiece is something about which there is an astonishing degree of unanimity. Changes of taste may keep the amateur amused, and we do not need to be reminded of the unexpected names that appear in the lists of great artists in the manuals of the 18th and early 19th centuries, usually headed by Giulio Romano. But if we examine what is in itself one of the most notorious examples of changing taste, the Albert Memorial, we find on the base a marble frieze of the great architects, painters and musicians who exemplify Prince Albert's interest in the arts (they were in fact chosen by Eastlake). They are, with one exception, almost exactly the same men whom we would choose today. Even the exception – Delaroche instead of Delacroix – is not so shocking as it would have seemed thirty years ago, as a large Delaroche now hangs in a place of honour in the National Gallery, dwarfing the neighbouring Delacroix. So I hope we can agree that masterpieces exist, and are the work of great artists in moments of particular enlightenment, and the question before us is why an artist has suddenly felt himself inspired. I will try and answer this question by examining some examples.

First of all, Donatello's *Annunciation* in Sta Croce. It seems simple, but anyone who has looked for long at this sublime work will have experienced a series of deep and complex emotions. To begin with he will, I suppose, be moved by the subject: that, if we are sincere, is probably our initial response to all works of art before the present century. Even if the spectator does not know who the Virgin Mary was, and what the angel is telling her (and I would imagine that the majority of those who have got as far as Sta Croce will have picked

9

up a few crumbs from the table of Christianity), even without some knowledge of what lies implicit in this scene, it must be apparent that a beautiful and profoundly human woman is receiving from some spiritual messenger information so fraught with doom and glory that she shrinks from it with her body and yet accepts it by the turn of her head. To anyone who knows the story of Christianity, and remembers the Virgin's sublime reply, 'Behold the handmaid of the Lord', the scene will be doubly moving. And yet we know that it would not fill our imaginations simply because it is an illustration. It does so because of Donatello's mastery of form. The composition, which looks almost obvious, turns out, on analysis, to have a long history. Donatello had, I believe, seen a Greek stele, either an original of the 5th century or a Hellenistic replica. He had been immediately struck with the beautiful finality of the design, and he probably recognized that the stele was a gravestone, the commemoration of someone who had died. He determined to bring it back to life, and in doing so reveals two of the characteristics of a masterpiece: a confluence of memories and emotions forming a single idea, and a power of recreating traditional forms so that they become expressive of

3 Detail from a Greek vase in the British Museum showing the burial of a warrior. This motif, taken up in Roman funerary art where it is known as the *pietà militare*, constitutes the ultimate source of Titian's composition

10

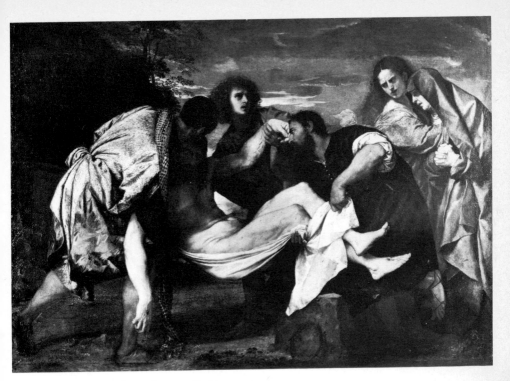

4 TITIAN, *Entombment* (Louvre, Paris)

the artist's own epoch and yet keep a relationship with the past. This instinctive feeling of tradition is not the result of conservatism, but is due to the fact that, in Lethaby's familiar words, slightly adapted, a masterpiece should not be 'one man thick, but many men thick'.

Let me give another example of this density, Titian's *Entombment* in the Louvre. As with the Donatello, it shows how a Classical idea may be so saturated with emotion that it becomes a masterpiece of Christian art. The motif of two men carrying a sagging body occurs in Graeco-Roman reliefs of the death of Meleager or the funeral of a Roman soldier (what is known as a *pietà militare*). Titian has kept the scaffolding, but used it as the pretext for a pictorial drama which marvellously expresses the tragedy of the subject. As with Donatello, he retains lines of communication with the immediate past. The head of St John is obviously Giorgionesque, and may even be an ideal

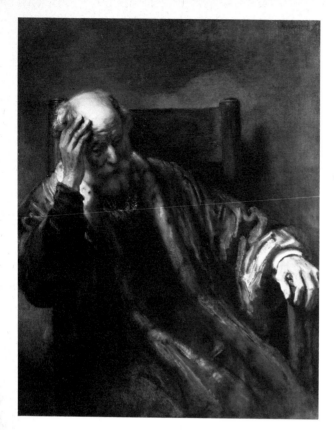

5 REMBRANDT, *Old man in an armchair* (National Gallery, London)

likeness of the inspired companion of his youth. Thus the *Entombment* has that double relationship with us, which is the prerogative of the masterpiece. It is a superb piece of design and a profound assertion of human values.

The human element is essential to a masterpiece. The artist must be deeply involved in the understanding of his fellow men. We can say that certain portraits are masterpieces because in them a human being is recreated and presented to us as an embodiment, almost a symbol, of all that we might ever find in the depths of our hearts. In this field Rembrandt is unique. Through him we commune with our own kind in a way that we could never have done without his penetrating eye. Do we know any living person as well as we know Mrs Trip?

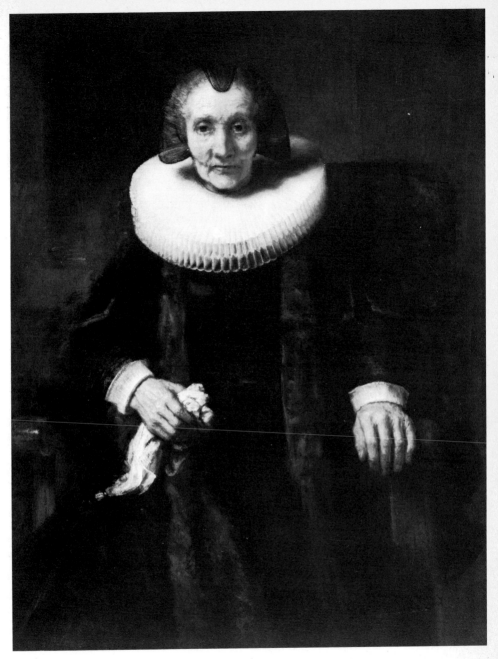

6 REMBRANDT, Detail from *Portrait of Margarethe de Geer, wife of Jacob Trip* (National Gallery, London)

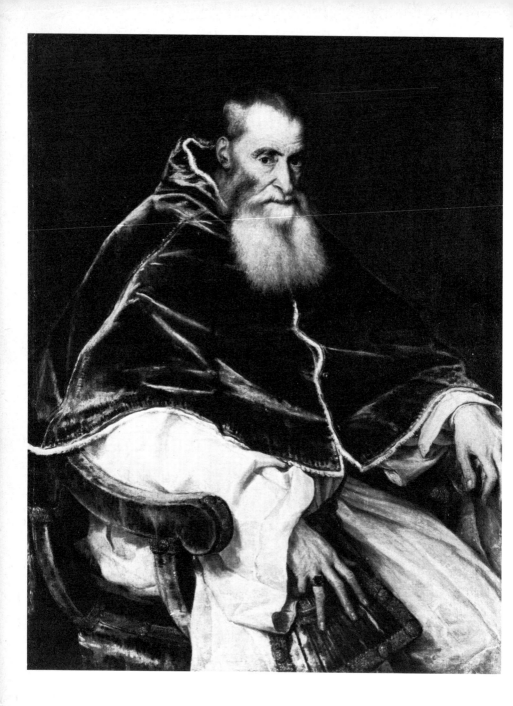

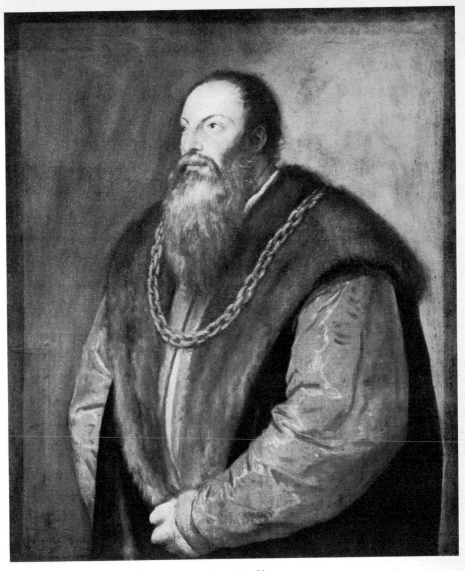

8 TITIAN, *Pietro Aretino* (Frick Collection, New York)

◁ 7 TITIAN, *Pope Paul III* (Museo di Capodimonte, Naples)

Great artist as Titian was, there is nearly always something external in his portraits. In a way he is too commanding. He shows the man but he does not become the man. I say 'nearly always' because once or twice the character of a sitter has dominated him so completely that a perfect fusion takes place. His portrait of *Pietro Aretino* looks at first like a show-piece, in which he has set out to make a scoundrel appear heroic, but the longer we look at it the more we recognize the powerful intelligence and courage that Titian discovered in his disreputable friend. He has become Aretino. An even more moving example of self-surrender to a complex character is his portrait of *Paul III* at Naples. One can look at him for an hour, as I have done, turning away and turning back, and discover something new at each turn. A wise old head, a cunning old fox, a man who has known his fellow men too well, a man who has known God. Titian has seen it all, and much more.

Rembrandt and Titian prove that great portraits can be masterpieces. But can we say that the straightforward portrait that appealed so much to both patrons and painters in the last century is worthy of that name? Manet and his circle thought that Velazquez was the greatest painter who had ever lived. Well, we may agree that devotion to truth is an attribute of the human mind from which a masterpiece may grow, and most people who are inclined to use the word masterpiece at all would apply it to *Las Meninas* of Velazquez. In the simplest meaning of the word, *Las Meninas* shows a devotion to truth that has never been equalled. But can mere imitation be the basis of a masterpiece? Before we indignantly answer 'no' we should ask what scale of visual impression is in question. A small detail – what used to be called a *trompe l'oeil* – can hardly claim to be a masterpiece. But when the discovery of truth is extended to a group of persons situated in a large room, and involved in a delicate human situation, then the painter's intellectual grasp and his technical skill can be combined to produce a masterpiece.

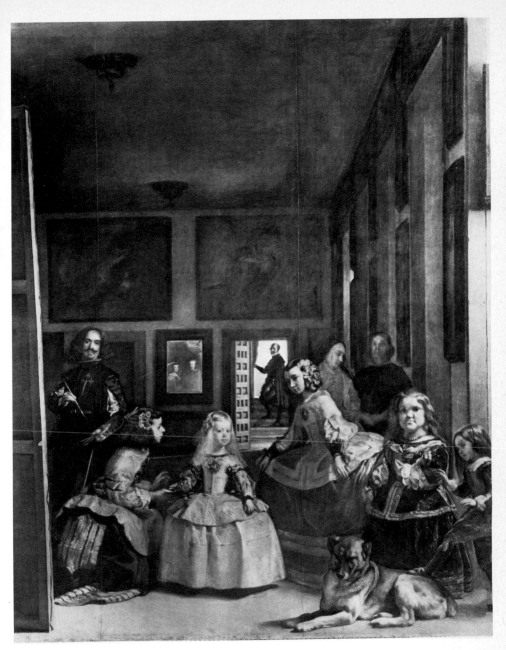

9 VELAZQUEZ, *Las Meninas* (Prado, Madrid)

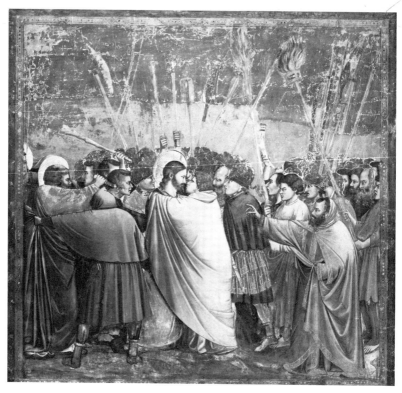

10 GIOTTO, *Betrayal of Christ* (Arena Chapel, Padua)

Actually it is very rare for a masterpiece to be achieved in this way, simply because the painter usually needs, in addition to these innate gifts, the stimulus of some dramatic situation. Let me support this statement by looking at a few of the greatest masterpieces of the past. To begin at the beginning, Giotto in the Arena Chapel. Was there ever a greater sequence of dramatic moments? Which shall I choose to remind you of these matchless experiences? Let me take the *Betrayal of Christ*. It is a masterly design. Everything in the picture leads us to look at the heads of Christ and Judas – the staves and torches, the draperies and of course the figures. And when we concentrate on the two heads, all pictorial designs are forgotten, and we think only of this

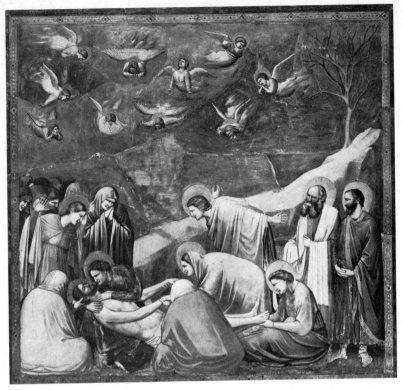

11 GIOTTO, *Lamentation over the Dead Christ* (Arena Chapel, Padua)

unforgettable confrontation. Judas, like some animal, half conscious
of the dreadful task that has been laid on him, and Christ, sternly
accepting this betrayal as part of his destiny.

And then, perhaps, the *Lamentation over the Dead Christ*, one of the
supreme compositions in art, and the origin of all those attempts to
relate figures to each other so that they could be rendered as a great
piece of sculpture. Those who demand of art a plastic sequence, and
what used to be called significant form, need not look further. But of
course they will, for every hand and every gesture leads to the head of
the Virgin gazing at her dead Son with an intensity that makes us
profoundly humble.

The Arena Chapel convinces us, surely, that the highest masterpieces *are illustrations of great themes*, and it has been the good fortune of European art that during its finest period it was called upon to concentrate almost exclusively on the Christian story. Although they will be so familiar to you, I cannot resist reminding you of some of the scenes of Christ's Passion in both Italian and Flemish painting that are at the very summit of European painting. They are almost all tragic. As in drama, Greek or Elizabethan, Racine or Schiller, it is the tragic element in life, and the finality of death, that lifts these painters to the highest plane. Mantegna's *Dead Christ* is something quite apart from the rest of his work, and springs from the idea that foreshortening, what is known as violent foreshortening, may be used to symbolize violence of feeling. At almost the same date, Bellini represented the dead Christ in a way at the furthest remove from that of his brother-in-law. Instead of inspired virtuosity, a deep humanity.

Two examples from the north. First, the *Descent from the Cross* by Roger van der Weyden. It is both concentrated and complex. The figures are effectively all on one plane, and could be rendered as sculpture. The composition could be analyzed in great detail. Every

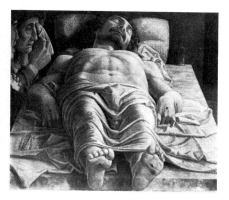

12 MANTEGNA, *Dead Christ*
(Brera, Milan)

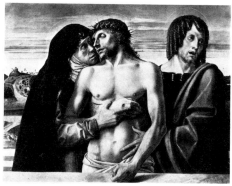

13 GIOVANNI BELLINI, *Pietà*
(Brera, Milan)

20

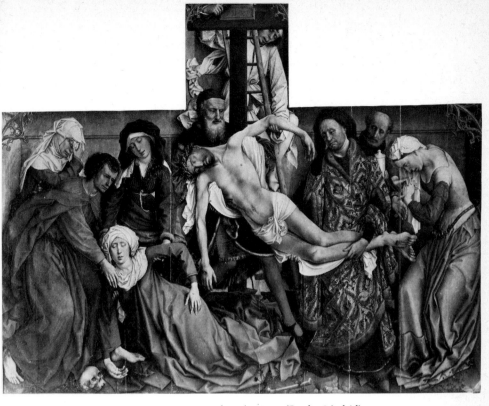

14 Roger van der Weyden, *Descent from the Cross* (Prado, Madrid)

part of it works, and no passages are included simply to please the eye.
I once wrote that the figures seem to have become art before they were
painted. And yet all this elaborate art is subservient to the subject. We
know that the descent from the Cross cannot have looked remotely
like this. But Roger's imaginative power, supported by his great
technical skill, forces us to suspend the criticisms of commonsense –
in fact, they do not even cross our minds. It is a triumph of art.

My other masterpiece of northern painting, the *Portinari Altar* of
Hugo van der Goes, is at the opposite pole. It does not aim at art, but
at truth. Instead of a frieze there is an open space. The first plane is
occupied by flowers in a very covetable vase, which seem to be

21

15 Hugo van der Goes,
Portinari Altar
(Uffizi, Florence)

occupying the attention of the kneeling angels much more than the Infant Christ. He really is an infant, and we are quite worried that his poor little body should be exposed in that way. As is usual with painters who take their subject from scripture, Hugo has paid no attention to St Luke's Gospel. Luke says three times that the babe was wrapped in swaddling clothes and laid in a manger. The shepherds came from a considerable distance, and the child in the manger would not have been the newborn babe in Hugo's picture. As so often, iconographical tradition leads an independent existence parallel with its sources.

Outside Venice, the second half of the 16th century is a depressing period. Form – or, as was then said, *maniera* – had ousted subject. But

22

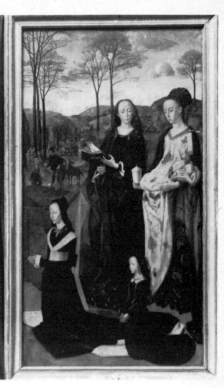

one painter, in his love of truth, painted masterpieces, Pieter Breughel. Although one can find in his backgrounds an echo of the delicate perception of nature of his Flemish predecessors, his vision of life was his own, and startlingly original. Who else would have painted the road to Calvary in which the place of crucifixion is in the distance and our attention is drawn to the thieves, who are being taken there on a cart. The extraordinary thing is that when he went to Rome in 1550 – the Rome of Giulio Romano and the Mannerists – he was greatly admired. Vasari called him '*un picolo e nuovo Michelangelo*'. The Roman connoisseurs admired equally both Breughel and Paolo Veronese, which looks like a sign of generosity, but was perhaps an admission of defeat similar to our own.

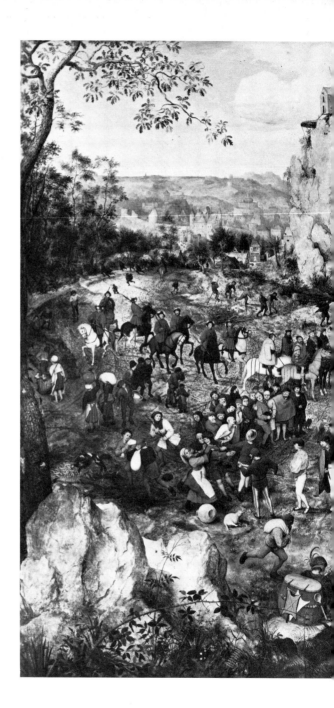

16 PIETER BREUGHEL,
Christ carrying the Cross
(Kunsthistorisches Museum,
Vienna)

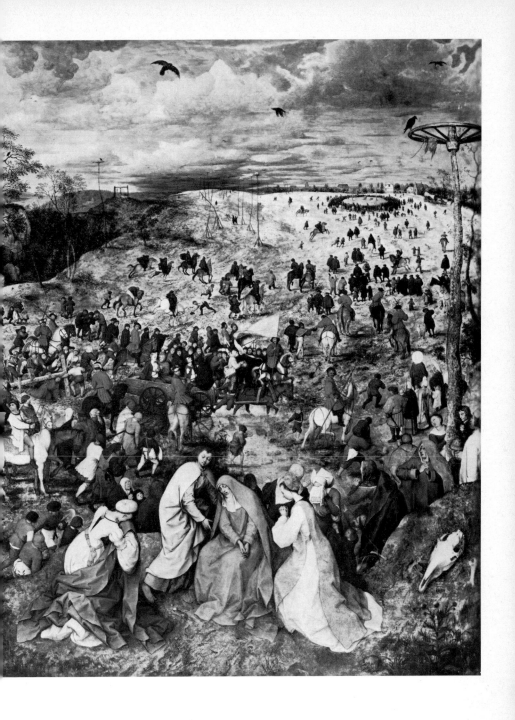

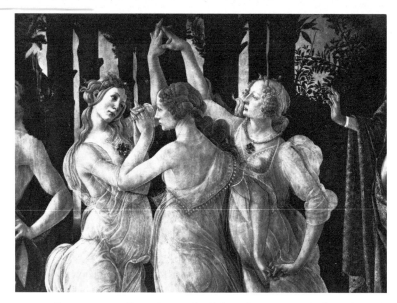

17 BOTTICELLI, Three Graces, detail from the *Primavera* (Uffizi, Florence)

Not a single masterpiece was painted in Rome between Michelangelo's frescoes in the Cappella Paolina and the Galleria of the Caracci in the Palazzo Farnese. Yet Rome was still considered the centre of European art, and for another century connoisseurs encouraged young painters to go to Rome. Most of them, like Rembrandt, refused. I hesitate to draw a parallel with Paris in 1945.

The Christian story is not the only subject of masterpieces. *The good life of the senses can be raised by imagination to the condition of poetry.* This, no doubt, had been the source of the greatest plastic and pictorial works of antique art, known to us only from replicas, and it was recreated in the Renaissance with something still of Gothic linearism in the work of Botticelli. Ultimately the beauty of his *Three Graces* expresses a deeply sensuous response, but it is rendered in a style so austere as to preclude the word sensual. His works hang at a point of balance never occupied before or since. The physical beauty of his Venus is so etherialized that we forget the fleshly instincts that were no doubt aroused by the antique Venus from which she was derived.

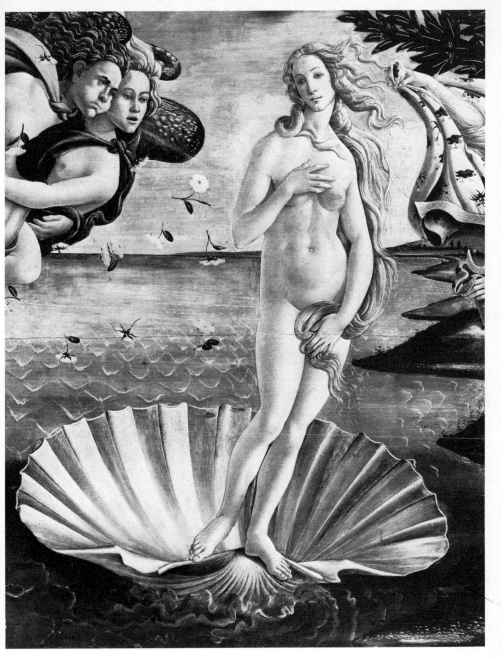

18 Botticelli, Venus, detail from *The Birth of Venus* (Uffizi, Florence)

In our search for masterpieces we must turn from Florence to Venice, where the sensuous response to beauty, strained and uneasy in Botticelli, was natural and direct. Giorgione's *Sleeping Venus* is a poem of sensual ecstasy so beautifully controlled that we hardly recognize it for what it is. But show the picture to a Philistine and there is no doubt what his reactions would be. Without our knowledge of the tradition of form that so perfectly encloses her body, this would seem to him simply a naked woman, the subject of desire, or perhaps of laughter. Once more we are aware that form and subject are one. If form predominates, as in many Mannerist and Neoclassical pictures, there is a loss of vitality and of that humanity which should underlie even the most idealized construction; but if subject predominates, as in the naturalistic painting of the 19th century, the mind releases its hold. In both cases the chance of a masterpiece is diminished.

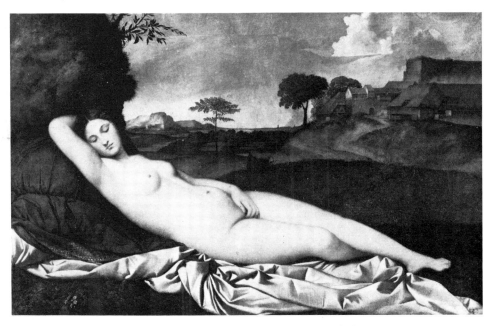

19 GIORGIONE, *Sleeping Venus* (Gemäldegalerie, Dresden)

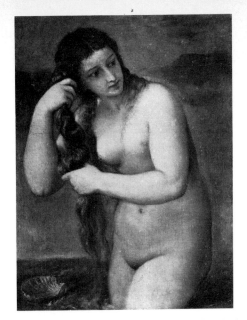
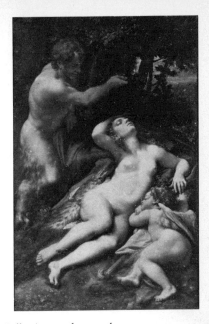

20 TITIAN, *Venus Anadyomene* (Duke of Sutherland's Collection, on loan to the National Gallery of Scotland, Edinburgh)
21 CORREGGIO, *Jupiter and Antiope* (Louvre, Paris)

The delights of the flesh, so delicately hinted at in Giorgione's *Sleeping Venus*, are accepted by Titian with an admirable simplicity. The body of his *Venus Anadyomene* is like a ripe fruit on a wall. But the picture is not erotic – indeed, I doubt if any picture so designated could be called a masterpiece. Eroticism is so strong a flavour that it would destroy the balance of sense and form that I have just mentioned. The nearest thing to an exception is the picture in the Louvre by Correggio of *Jupiter and Antiope*, but there the inviting pose is an essential part of the subject.

The immense spiritual energy that had produced Leonardo da Vinci, Michelangelo, Raphael and Titian seemed to have been exhausted in the second half of the 16th century, and for masterpieces outside Venice we have to wait fifty years for Caravaggio. In some respects he was not an original painter; he was a High Renaissance

29

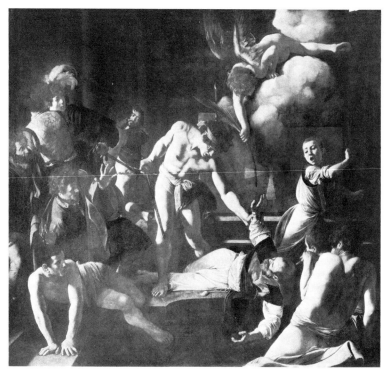

22 CARAVAGGIO, *The Martyrdom of St Matthew* (S. Luigi dei Francesi, Rome)

painter turned bad. He could paint an altarpiece built up like a Raphael, with the pointing hands and over-expressive heads of the Transfiguration. The *Madonna del Rosario* is a wonderful piece of picture making, but I do not think of it as a masterpiece because in it Caravaggio is not really himself. The drama, the violence, the cruelty that makes us fear him almost as much as he was feared in his own day have been suppressed. But he *was* a painter of masterpieces. There are no small or trivial Caravaggios. Each one is a blow in the pit of the stomach and, as we gradually recover from the shock, we see that the mastery has been sustained down to the smallest detail. Effective revolutions depend on convincing details.

30

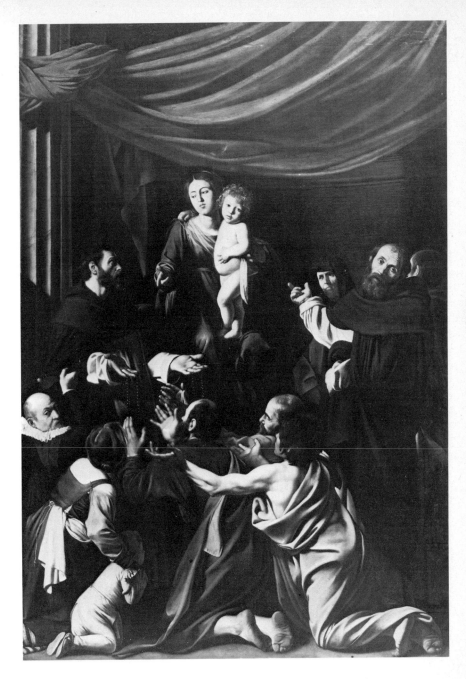

23 CARAVAGGIO, *Madonna del Rosario* (Kunsthistorisches Museum, Vienna)

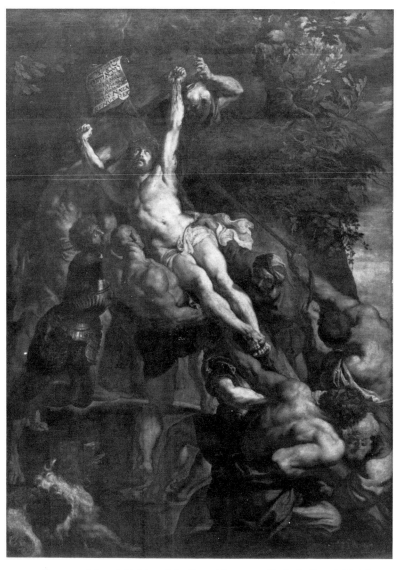

24, 25 RUBENS (above) *Raising of the Cross* (Antwerp Cathedral) and (right) *Descent from the Cross* (Palais des Beaux Arts, Lille)

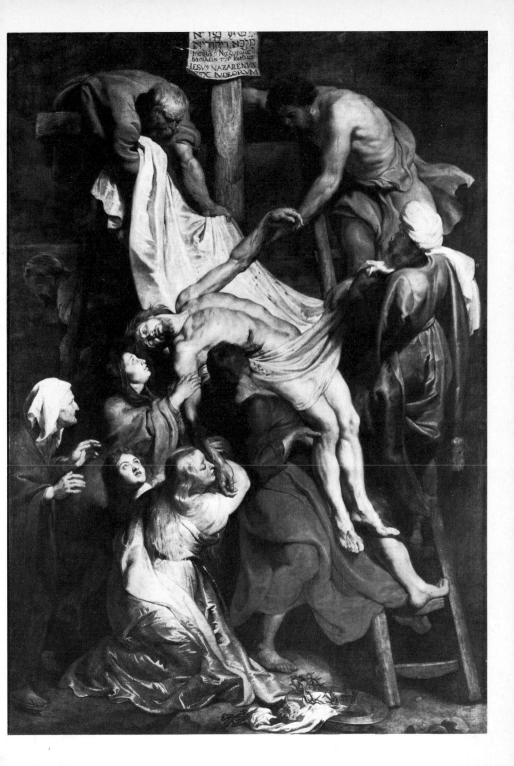

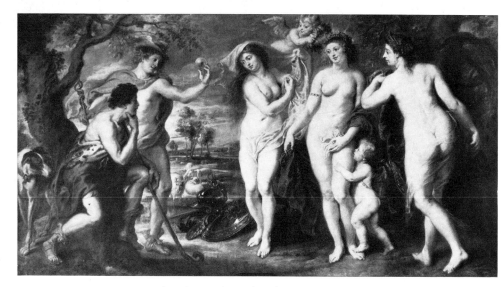

26 RUBENS, *The Judgment of Paris* (Prado, Madrid)

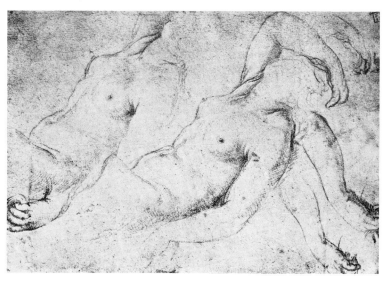

27 RUBENS, Chalk drawing of a female nude (Private collection)

34

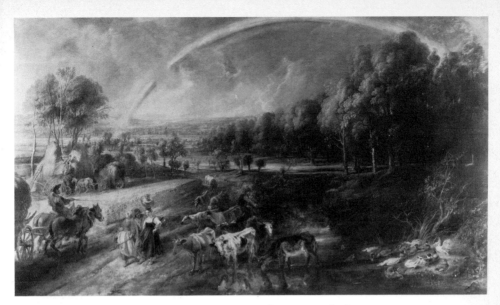

28 RUBENS, *Landscape with Rainbow* (Wallace Collection, London)

Whatever he may mean to us, there is no doubt about what Caravaggio meant to his immediate successors: escape from the packaged diet of the Mannerist style and freedom to develop in every direction. No painter has had so many men of genius among his followers; because I think we may safely say that neither Rubens, nor Velazquez nor Rembrandt would have been the same without him. It is strange that Rubens, that great master of the good life, should have drawn inspiration from so harsh a source. But Rubens, that wonderfully balanced human being, was not a sensualist. Anyone who has been to his native town of Antwerp will carry away the impression of the greatest religious painter of the early 17th century. His marvellous skill is completely at the service of his deep religious feeling, and the fact that we can no longer imagine a man with such an appetite for life being so deeply moved by the thought of the death of Christ is a criticism of us, not of Rubens. His greatest masterpieces are Christian pictures. But his evocations of the senses are masterpieces too – not only the pictures of glowing flesh, by which he

35

is popularly remembered, but his response to nature, from the smallest detail to the largest perspective. Which reminds us that happiness, which plays so little part in the speculations of philosophers or theologians, is sometimes of great importance in our lives. No one, I hope, would deny that Watteau's *Embarkation for the Island of Cythera* is a masterpiece, and although critics have detected a vein of delicate melancholy in Watteau, it is surely a poem in praise of happiness. Whether the pilgrims to Cythera will ever reach it is beside the point. They are going in search of it, as the first object in life.

Rubens was a happy man of action who was also a painter of genius. Velazquez was a true professional. It is tempting to say that masterpieces are not painted by professionals. They demand a wider contact with life. This was half true of Leonardo, Raphael and Michelangelo, but not, I suppose, of Titian, and it is eminently untrue of Velazquez. And yet one must admit that his strangely impersonal portraits *are* masterpieces, in which Velazquez's reticence becomes almost a moral quality.

29 WATTEAU, *Embarkation for the Island of Cythera* (Louvre, Paris)

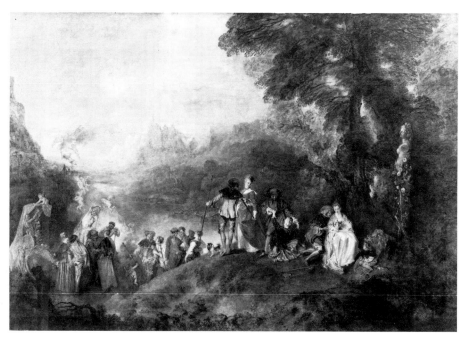

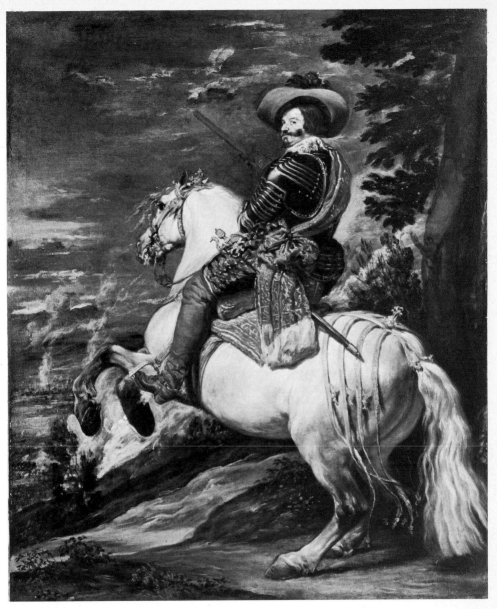

30 VELAZQUEZ, *Don Gaspar de Guzmán, Count Duke of Olivares* (Metropolitan Museum of Art, New York; Fletcher Fund, 1952)

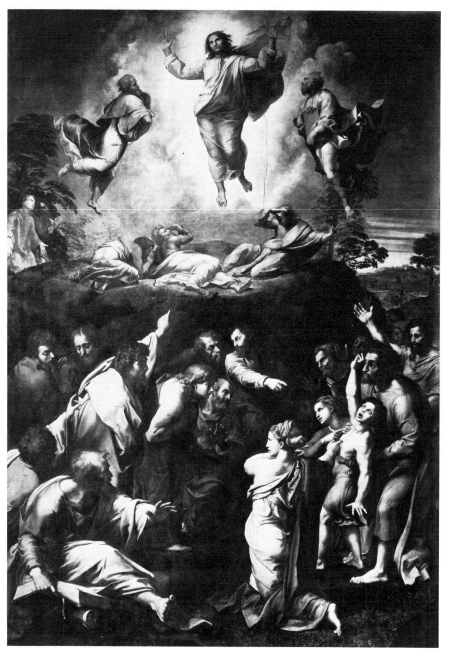

31 RAPHAEL, *The Transfiguration* (Vatican Gallery, Rome)

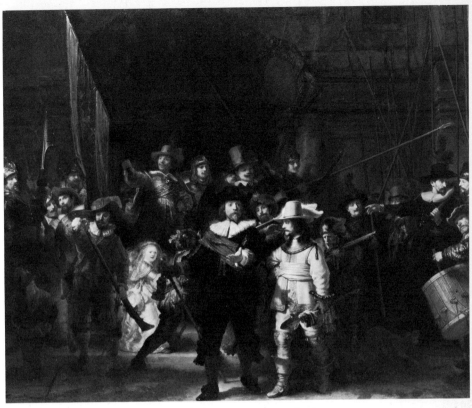

32 REMBRANDT, *The Night Watch* (Rijksmuseum, Amsterdam)

There remains a sense of the word masterpiece that I have not
touched on, although it may perhaps be one that is uppermost in
many people's minds when they use the word. They think of those
large, elaborate works in which a painter has put in everything he
knows in order to show his complete supremacy in his art. There are
works that are usually made the centre of any study of a master's
oeuvre: Raphael's *Transfiguration*, Michelangelo's *Last Judgment*,
Tintoretto's *Crucifixion*, Rembrandt's *Night Watch*, Géricault's *Raft
of the 'Medusa'*. Unquestionably they are masterpieces. We stand

39

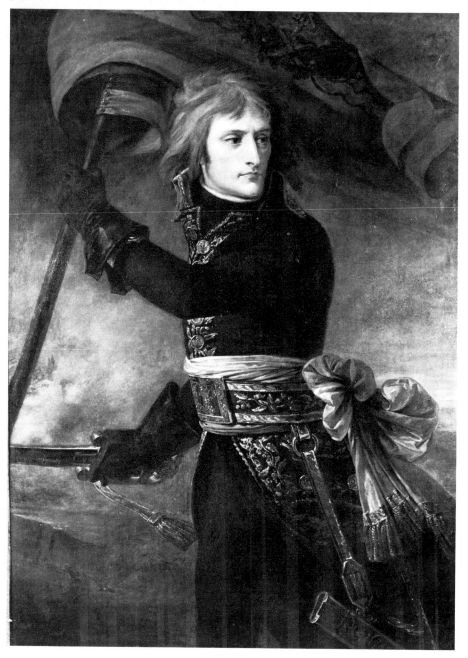

33 Baron Gros, *Napoleon at the Bridge of Arcola* (Versailles)

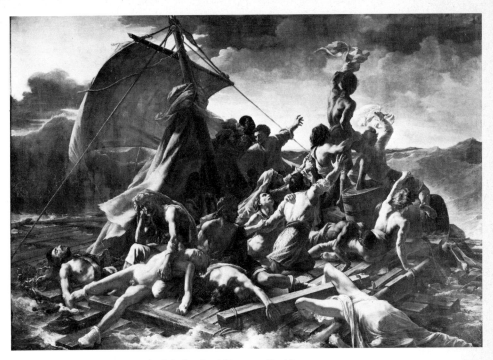

34 GÉRICAULT, *The Raft of the 'Medusa'* (Louvre, Paris)

silently before them, and try to feel some of the emotions that overwhelmed amateurs and historians of art in the last century. I do not say that we are altogether unsuccessful. We feel an immense respect, and even an amazement that the painter has been able to dominate such a mass of material, and if we do not immediately respond, that may be due to many accidental distractions. Crowds, guides, haste or hunger may intervene. But beyond this is a sense of inadequacy – personal inadequacy, and the inadequacy of our own times. By these works all modern painting is condemned. In the Scuola di S Rocco the authorities have cut out and framed a small piece of the decorative border of Tintoretto's *Crucifixion*, and have

41

Put into historical perspective

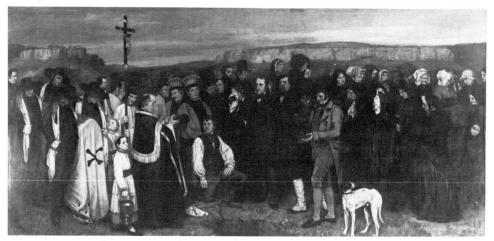

35 COURBET, *Funeral at Ornans* (Louvre, Paris)

exhibited it in the same gallery – I suppose to show what the original colour was like. Sitting in that awe-inspiring room for long periods, I have been interested to observe how many visitors soon turn away from Tintoretto's masterpiece, and look with relief at the relatively insignificant fragment. It is certainly much more like a modern painting than the *Crucifixion*.

A change of scale: it was the simplest, but one of the most influential changes that took place in late 19th-century European painting. In the first half of the century the heroic scale was in the ascendancy. The great pictures of David, Géricault, Delacroix and the Baron Gros that fill two huge rooms in the Louvre are indisputably what are known as masterpieces. Baron Gros is as far as one can go in official romantic painting. The last of these great canvases, Courbet's *Funeral at Ornans*, is also the funeral of painting on a grand scale. After 1870, and perhaps not unconnected with the change of French social structure, although such connections are always suspect, the masterpiece contracts. It does not disappear.

Manet's *Olympia* is a masterpiece all right. But pictures that, by their scale and pretension, might once have had a claim to be called masterpieces are dead. Even Puvis de Chavannes, thought by his serious contemporaries to be unquestionably the greatest painter of his time, does not often make one's heart beat faster. This is the summit of virtuous official art, and the living art of the time was not virtuous.

Which leads to the conclusion, already foreshadowed, that a masterpiece must use the language of the day, however degraded it may seem. What if that language, for certain complex reasons, has become incomprehensible to the majority of men and women? Can we say that the great cubist pictures of Picasso are masterpieces? I think we can. A picture like the *Woman with a Guitar*, which seemed

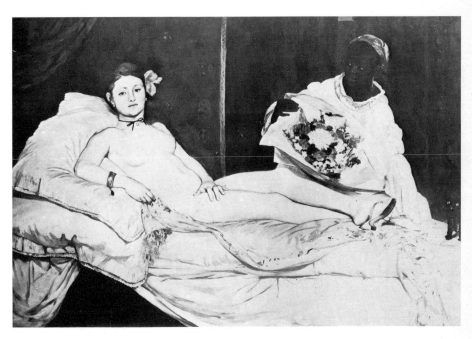

36 MANET, *Olympia* (Musée du Jeu de Paume, Paris)

so esoteric when it was painted in 1911, now offers no difficulties to anyone with a sense of animated design. As for *Guernica*: surely anyone seeing it for the first time must be, to use a popular expression, knocked sideways. It is almost impossible to believe that when it was first exhibited in the Spanish Pavilion at the Paris World's Fair of 1937 it was attacked by almost all *highbrow* critics. They said that it was a betrayal of those principles that they had painfully learnt to recognize in the *Woman with a Guitar*. The triumph of *Guernica* was to a large extent a popular triumph. And if we call the cubist pictures masterpieces in a limited sense we can call *Guernica* a masterpiece in the extended sense that I have tried to use here. It is not merely a superb piece of technical skill, it is the record of a profound and a prophetic experience. No one can analyze its subject. Many of the ideas it contains go back to before the bombing of Guernica; the confused horror of its general impression looks forward to coming war. But above all it represents, or symbolizes, a society in the throes of destruction, as convincingly as Raphael's *School of Athens* represents society in perfect equilibrium.

Thus I return to my original position. Although many meanings cluster round the word masterpiece, it is above all the work of an artist of genius who has been absorbed by the spirit of the time in a way that has made his individual experiences universal. If he is fortunate enough to live in a time when many moving pictorial ideas are current, his chances of creating a masterpiece are greatly increased. If, to put it crudely, the acceptable subjects of painting are serious themes, touching us at many levels, he is well on his way. But in the end a masterpiece will be the creation of his own genius.

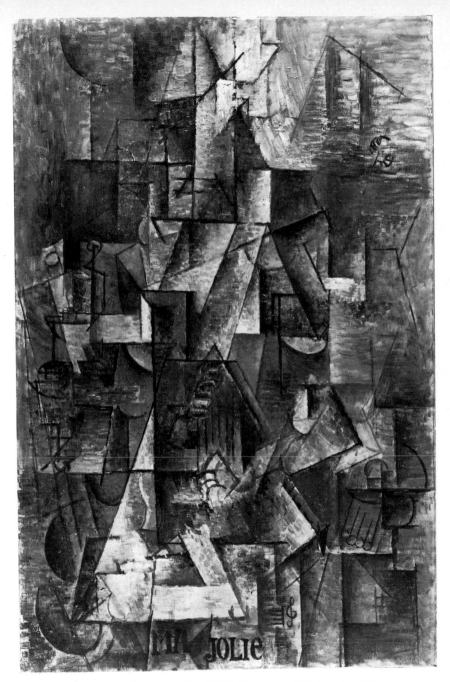

37 PICASSO, *Woman with a Guitar* ('Ma Jolie') (Museum of Modern Art, New York; Lillie P. Bliss Bequest)

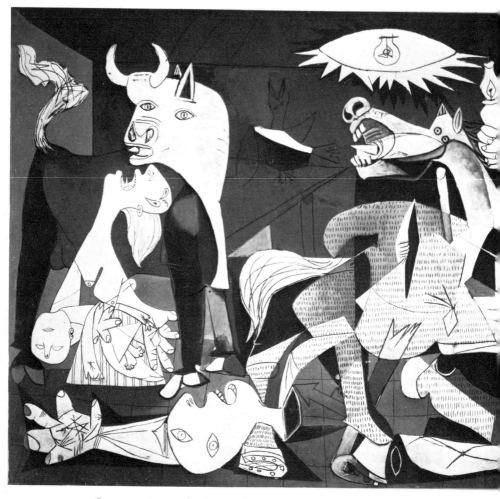

38 PICASSO, *Guernica* (on loan to the Museum of Modern Art, New York)

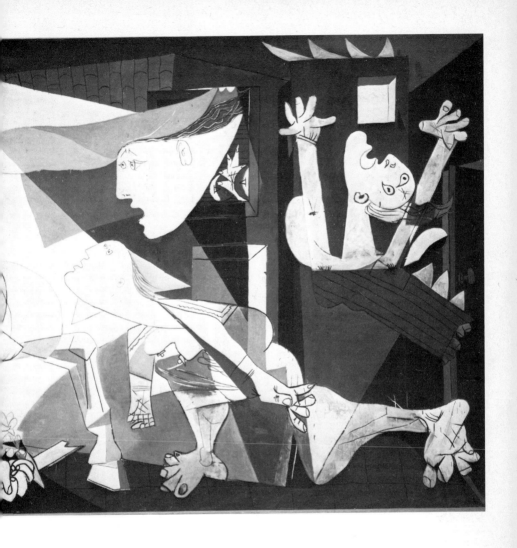

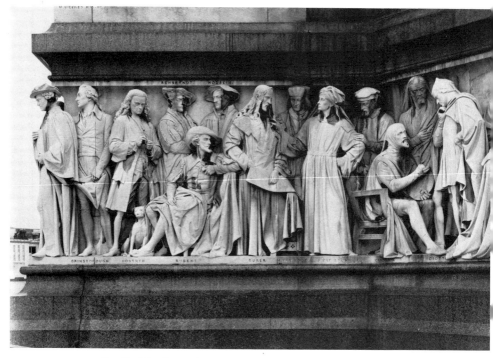

39 Detail of the frieze of the Albert Memorial, London, showing the world's greatest artists as chosen by Sir Charles Eastlake. This section includes (from right to left) Giotto, Orcagna, Cimabue, Stephen of Cologne (Stefan Lochner), Jan and Hubert van Eyck, Dürer, Holbein, Rubens, Rembrandt, Hogarth (with dog), Gainsborough and Reynolds

PHOTOGRAPHIC ACKNOWLEDGMENTS

Photographs have been supplied by the galleries and museums where the pictures are located, with the following exceptions:
ACL, Brussels 24; Alinari 2, 10, 11, 12, 15, 17, 18, 31; Alinari/Anderson 13, 22; Bulloz 35; Giraudon 21, 25, 29, 33, 34; Lauros/Giraudon 3; Soprintendenza alle Gallerie, Naples 7; Eileen Tweedy 39.

48